CW01371449

FRANK QUITELY
DRAWINGS + SKETCHES

Drawn and written by: Frank Quitely
Publication design by: Kirsty Hunter
Edited by: Nicola Love
Photography by: Mark Boyle
First printing 2018
Published in Glasgow by BHP Comics Ltd
ISBN: 978-1910775097

All rights reserved. No part of this publication can be reproduced or transmitted in any form (except short excerpts for review purposes) without written permission from the publisher.

All illustrations in the book are copyright of their respective copyright holders (according to the original copyright or publication date as printed in the comics) and are reproduced for historical purposes. Any omission or incorrect information should be transmitted to the author or publisher so that it can be rectified in any future edition.

Extracts from the sketchbooks of Frank Quitely copyright © 2018

Made in Scotland. Printed in Great Britain by Bell & Bain Ltd, Glasgow
A CIP catalogue reference for this book is available from the British Library
Ask your local comic or bookshop to stock BHP Comics. Visit **BHPcomics.com** for more info.

CONTENTS

JUPITER'S LEGACY 2
JUPITER'S CIRCLE 20
PAX AMERICANA 34
NOTHING TO DECLARE 60
WE3 .. 78
MISCELLANEOUS 90

JUPITER'S LEGACY

4 | **FRANK QUITELY** Drawings + Sketches

"Jupiter's Legacy was a creator-owned project I worked on alongside Mark Millar about the the generational conflict between a group of aging superheroes known as the Union."

Development sketches for **Jupiter's Legacy** covers.

JUPITER'S LEGACY | 5

Above (From left to right): Jupiter's Legacy vol.2, #5 (writer: Mark Millar, Netflix Studios, 2017) cover. Lighting guide, digital blue line sketch and pencils.

Right: As above. Finished art, digital colour.

"I actually sent Mark Millar a coloured rough for this cover. I had this idea of having a starburst effect because it's Chloe and Brandon, two immensely powerful people, facing off. I wanted it to look like they were at the centre of an explosion. He loved it. I did the finished linework in pencil and coloured it digitally. I did the colouring in the same way I would if I was using coloured pencils or a tiny paintbrush, with the same radial quality moving out from the centre.

This was one of those rare occasions when I did a few roughs and two covers were instantly worked out. Usually I have dozens of variations for one cover until I get to something I'm happy with. These designs came to me really quickly – the other being the cover of Uncle Walter standing in front of Skyfox."

6 | **FRANK QUITELY** Drawings + Sketches

Jupiter's Legacy
vol.2, #4 (writer: Mark Millar, Netflix Studios, 2017) cover.

This page:

Above: Digital sketches of Skyfox's face, showing the positioning of his mask.

Below: Pencils over blue line and finished cover art with digital colours.

Opposite page: Blue line digital sketch.

JUPITER'S LEGACY | 7

8 | FRANK QUITELY Drawings + Sketches

Jupiter's Legacy vol.2, #2, (writer: Mark Millar, Netflix Studios, 2016) cover. Finished art, full colour digital.

Above left: Blue line digital sketch.

Above: Pencils over blue line.

Opposite page: Finished art, full colour digital.

"This is a cover of Repro, I added rose petal details for an extra touch of Bollywood glamour."

10 | **FRANK QUITELY** Drawings + Sketches

"This is a page from my sketchbox that got damaged. It stays in my bag and I take it on the bus to work ... and my bottle of water spilled. I was obviously using cheap pens but it was a nice effect."

JUPITER'S LEGACY | 11

"When I'm deciding how a character should look, I'm drawing in my sketchbook whilst thinking about the character as they're described in the script. When you're given a description of the appearance or behavior of someone you haven't seen before - and this is the case for all of us when we're reading a book, or listening to someone telling us about someone they know - we start to form a mental image.

"I do that as I'm drawing and I often get pulled in the direction of one or some of the many mental images I have in my memory and imagination. It could just be an archetype, it could be a particular actor or politician or a teacher I had at school — and I'll start basing my designs on these."

12 | **FRANK QUITELY** Drawings + Sketches

The setup for the scene is that the Union are facing off against villain Blackstar on a hillside. They're fighting a losing battle until Brainwave (Walter Sampson) comes along and traps him in a psychic cell, which renders his physical form powerless against the heroes.

JUPITER'S LEGACY | 13

When I saw the script, I was thinking in terms of a prison cell and an animation cel. The way I represented the psychic cell is a visual explanation of the way Brainwave is creating it in the story; the position the bad guy's in and the gentle incline of the slope all mirror the physical environment of the panel above it. While the physic prison cell is a different environment, made from imagination and memories by Brainwave to contain Blackstar, the idea was to create a cube in perspective.

14 | **FRANK QUITELY** Drawings + Sketches

JUPITER'S LEGACY | 15

Left: **Jupiter's Legacy** vol.1, #1 (writer: Mark Millar, Netflix Studios 2013) pp.13. Digital colours by colours Peter Doherty.

16 | **FRANK QUITELY** Drawings + Sketches

Above: Jupiter's Legacy vol.2, #1 (writer: Mark Millar, Netflix Studios, 2016) pp.17-18. Pencils over blueline.

Below: Sketchbook detail showing the composition of the main panel.

18 | **FRANK QUITELY** Drawings + Sketches

Above: Jupiter's Legacy vol.2, issue #2
(writer: Mark Millar, Netflix Studios, 2016)
pp.17. Pencils over blueline.

JUPITER'S CIRCLE

22 | **FRANK QUITELY** Drawings + Sketches

Teen Scene, the teenage superteam to the Union in Jupiter's Circle

JUPITER'S CIRCLE | 23

Jupiter's Circle vol.1, issue #2 (writer: Mark Millar, Netflix Studios, 2016) cover. Pencils over blueline.

24 | **FRANK QUITELY** Drawings + Sketches

"Because I had drawn both volumes of Jupiter's Legacy, Mark wanted me to design the characters for Jupiter's Circle, though the interior artwork was drawn by someone else. I also did the covers.

This is the first cover for Jupiter's Circle. I like the design but looking back, the drawing itself looks a little uptight. Sometimes I get into a flow and the linework is nice and easy, other times it's not. I don't think most people notice a difference but it's so obvious to me."

Right: **Jupiter's Circle** vol.1, #1 (writer: Mark Millar, Netflix Studios, 2016) cover.

26 | **FRANK QUITELY** Drawings + Sketches

Digital roughs for design of robot villian for Jupiter's Circle.

JUPITER'S CIRCLE | 27

Colour options for final design.

28 | **FRANK QUITELY** Drawings + Sketches

Utopian aka Sheldon Sampson

JUPITER'S CIRCLE | 29

Lady Liberty aka Grace Sampson

30 | **FRANK QUITELY** Drawings + Sketches

JUPITER'S CIRCLE | 31

Opposite page:
Jupiter's Circle vol. 1, #6 (writer: Mark Millar, Netflix Studios, 2015) cover.

This page: Pencils over blue line.

32 | **FRANK QUITELY** Drawings + Sketches

Jupiter's Circle vol. 1, #2 (writer: Mark Millar, Netflix Studios, 2015) cover.

JUPITER'S CIRCLE | 33

"When I draw covers, I usually add little details to amuse myself. There's a vase in the background of this cover. It's barely visible in perspective but it has a topless Grecian guy with a top knot, I thought it might be something this character would own."

PAX AMERICANA

36 | FRANK QUITELY Drawings + Sketches

Grant's roughs

"Pax Americana was one of the difficult, most time-consuming books I've ever worked on. It was a particularly hard project in terms of storytelling. Like We3, there were a few pages which Grant Morrison sent into the editor and said that we were going to get together and work it out. There was no description, it just said that he needed to speak to me.

The story is told in reverse chronological order, so it starts by rewinding the assassination of President Harley by the Peacemaker to the revelation that Harley murdered his own dad as a young boy. This sequence shows a young Harley creeping into his dad's studio to look through his work as a comic book artist.

FQ Roughs

While he's there, Harley discovers a gun in the top drawer. When his dad appears wearing a superhero costume, Harley shoots and kills him. That sequence is the only time I've worked with Grant when he's given me thumbnails. Sometimes I found it helpful and sometimes I found it very difficult.

Some of them worked and some of them didn't work well enough to suit me and I had to change them. Because I was trying to stick to his layout, it mean that the changes I made and the problem-solving. I had to do was in a much tighter space so it ended up taking longer than if I had laid it out myself.

PAX AMERICANA | 39

"In the interest of accuracy, I made a digital version of the room in perspective instead of using my loose drawing which, strictly speaking, would've been good enough.

I decided the way I wanted it to work was that the top four panels of the page work as sections of one scene or one viewpoint – and the same with the bottom four panels. It was different from how Grant wanted to do it, I thought it would suit the tightness and design of the book. It's a very contrived kind of story; everything ties to something else."

"Once I'd finished the basic underdrawing for the page, I added the drawings and charts on the studio walls, the newspaper clippings in the scrapbook, the half-drawn comic page on the desk, all shown opposite in black against the blue underdrawing. The newspaper clippings I drew flat, then bent them digitally to fit the curve of the scrapbook pages on the fifth panel."

"The following pages show the rest of the process, from the final blue underdrawing, to pencils, inks, and finally Nathan Fairbairn's colours."

The Multiversity: Pax Americana, 'In Which We Burn'
(writer: Grant Morrison, DC Comics, 2015) pp.35. Digital assets over blueline..

42 | **FRANK QUITELY** Drawings + Sketches

The Multiversity: Pax Americana, 'In Which We Burn'
(writer: Grant Morrison, DC Comics, 2015) pp.35. Finished blueline..

PAX AMERICANA | 43

The Multiversity: Pax Americana, 'In Which We Burn'
(writer: Grant Morrison, DC Comics, 2015) pp.35. Finished pencils.

44 | **FRANK QUITELY** Drawings + Sketches

The Multiversity: Pax Americana, 'In Which We Burn'
(writer: Grant Morrison, DC Comics, 2015) pp.35. Finished inks.

The Multiversity: Pax Americana, 'In Which We Burn'
(writer: Grant Morrison, DC Comics, 2015) pp.35. Finished page.

"There have been a couple of times I've worked with Grant where there have been pages of script with no description, just a note to the editor saying he and I are going to get together to work it out. The last was for a double-page spread for Pax Americana, the time before that was We3.

Grant's initial idea was to use the interior of the Peacemaker's digs and have him and his girlfriend walking around up and down stairs. The murderer was going to be sneaking about chasing them, then the Question was going to be going around with his torch. He wanted those three stories, set across three different

MOONLIGHT ON BALCONY

DRAWER
DOOR
SHU

BATH
ROBE

GLOW.

times, in the same place. He had this idea that the only way to do this would be go up and down stairs, but he also wanted it to read like a normal double-page spread where you read from left to right across four rows.

After trying it a few times, it didn't seem like it was going to work - so I asked him to tell me what was actually happening. When he described it, I suggested trying it in a big flat room. It worked more easily in a simpler perspective."

48 | **FRANK QUITELY** Drawings + Sketches

PAX AMERICANA | 49

The Multiversity: Pax Americana, 'In Which We Burn'
(writer: Grant Morrison, DC Comics, 2015) pp.12-13. Finished blueline.

50 | **FRANK QUITELY** Drawings + Sketches

PAX AMERICANA | 51

The Multiversity: Pax Americana, 'In Which We Burn'
(writer: Grant Morrison, DC Comics, 2015) pp.12-13. Pencils.

52 | **FRANK QUITELY** Drawings + Sketches

PAX AMERICANA | 53

The Multiversity: Pax Americana, 'In Which We Burn'
(writer: Grant Morrison, DC Comics, 2015) pp.12-13. Finished inks.

54 | **FRANK QUITELY** Drawings + Sketches

"You can see my digital underdrawing in blue, the finished pencils and a rough guide for the colourist. The yellow areas are late morning, when the Peacemaker is getting ready to leave and his girlfriend is asking him to stay, the red areas are when his girlfriend is about to be attacked in the house, and the blue panels are when the Question comes in to talk us through after the police investigation. It's not the colourist's job to draw in perspective shadows from the different angles where I want the light to come from, so this is me doing a detailed shadow guide (overleaf). Same with the blood stains. This page definitely needed the colouring to sell the three different times, just as you need the large objects that overlap the panels to sell the space."

56 | **FRANK QUITELY** Drawings + Sketches

PAX AMERICANA | 57

The Multiversity: Pax Americana, 'In Which We Burn'
(writer: Grant Morrison, DC Comics, 2015) pp.12-13. Shadow guide.

The Multiversity: Pax Americana, 'In Which We Burn'
(writer: Grant Morrison, DC Comics, 2015) pp.12-13. Finished page.

SCRATCHES 118x

WENDY

[X] 212

NOTHING TO DECLARE

62 | **FRANK QUITELY** Drawings + Sketches

NOTHING TO DECLARE | 63

"**Nothing to Declare** is a horror story about a backpacker who comes home for Christmas Eve to see his family but his excitement quickly turns to terror. It was originally going to be a short comic book story, the working title for which was The Cordycep Story. The basic idea for the story stayed the same but along the way, nearly all the other elements changed.

I started working with two Scottish animation companies, **Once Were Farmers** and **Interference Pattern**, and the medium changed from a comic book into a short film. It became a different way of telling a similar kind of story. I started with a series of thumbnails showing the main character trying to get into a house. In this version of the story, several of the people were still alive. Because we were working on a tight budget, we rewrote the script so that only one person was alive and everyone else in the house was already dead. Changing something I was creatively happy with for monetary reasons was an interesting experience."

64 | FRANK QUITELY Drawings + Sketches

Inital thumbnail floorplan sketches for Nothing to Declare as a comic book short story

66 | **FRANK QUITELY** Drawings + Sketches

"From my early character designs, the animators told me I was guilty of something they call uncanny valley — when you have something which looks so realistic that, when you animate it, it looks oddly unconvincing. I had to make the characters more stylised so they were easier for them to work with."

NOTHING TO DECLARE | 67

Left to right: Rough character sketches, digital pencils, colouring over top of initial sketches and completed digital character designs.

NOTHING TO DECLARE | 69

70 | **FRANK QUITELY** Drawings + Sketches

NOTHING TO DECLARE | 71

Completed character designs for the parents in Nothing to Declare

72 | **FRANK QUITELY** Drawings + Sketches

NOTHING TO DECLARE | 73

"This is a drawing showing the fate of the sister in Nothing to Declare. I took a photo of my sketchbook and added digital colouring over the top. The animators were looking for something to build the bedrooms and I liked this sketch; I saw the scene as a dull room with dramatic lighting, so it was simple to achieve that digitally.

"A lot of my process is relatively low-tech, I think I used a printing roller to prop the sketchbook open for the photo - obviously I hadn't intended on sharing it at the time..."

74 | **FRANK QUITELY** Drawings + Sketches

NOTHING TO DECLARE | 75

This page: Digitally coloured pencil sketches.

Opposite: Digital sketch.

76 **FRANK QUITELY** Drawings + Sketches

NOTHING TO DECLARE | 77

Nothing to Declare premiered at Edinburgh International Film Festival in 2017.

Digital stills from Nothing to Declare.

WE 3

80 | **FRANK QUITELY** Drawings + Sketches

"Grant wanted the action sequences in We3 to suggest the heightened senses of the animals, which allowed us to get creative with the page layouts. We treated some of the pages as 3D spaces where panels were hung, rotated or layered on top of each other.

"The most difficult part of the book to plan was the six-page CCTV sequence. It was too complicated for me to work out in my head and it was proving difficult on paper because there were so many different variables, so I drew each of the 108 thumbnails out individually and colour coded to show the different camera angles - that way I could rearrange them the way I wanted to. It took a lot of time to prepare but it made it easier to get the storytelling right.

"I kept all the cut-outs in a raisin box, which my wife actually threw away one day, not realising it contained about two weeks' worth of work. Luckily I managed to fish it out the bin in time."

82 | **FRANK QUITELY** Drawings + Sketches

Display in Frank Quitely: The Art of Comics exhibition in Kelvingrove Museum and Art Gallery.

"Frank and I are creating what I'm calling the "pop-out" effect, which is all about thinking past the apparent "flatness" of the 2D page surface and visualising the page as having infinite white DEPTH. This allows for a new kind of "camera-eye" for comics, panels can "pop" out of the page or sink into the page etc. It's all worked out visually and will change comics forever ... Let Hollywood TRY to copy this."

– Grant Morrison writing We3 script to Karen Berger

"This was one of the sequences that popped out of the page in a 3D way. Small animals experience time more slowly, so there was the idea of extending the gutters around the panels to suggest the immense amounts of still time a cat might pass through in microseconds of human awareness. It's a fight sequence with the cat moving through panels set in perspective, through which we see that the background is a continuous panorama."

We3: The Deluxe Edition (writer Grant Morrison, Vertigo, 2004-2005)
pp.54-55. Finished pencil.

"The dog leaps at the windscreen of the second jeep. We're right in there with the men as the monstrous cyborg comes straight at us. Firing a single missile from its back cannon. These are not cuddly animals to f*** with, no sir!"
– Grant Morrison in We3 script

LOST RABBIT

CAN YOU HELP US FIND PIRATE?

He is white with a ~~patch de or~~ brown patch over his eye.
He likes lettuce and carrots.

thank you,
Johnny and claire.

WE3 | 87

88 | **FRANK QUITELY** Drawings + Sketches

We3: The Deluxe Edition (writer Grant Morrison, Vertigo, 2004-2005) pp.50-51.

MISCELLANEOUS

92 | **FRANK QUITELY** Drawings + Sketches

"The Citizens Theatre in Glasgow put on a production of The Gorbals Vampire in 2016 and I was commissioned to create the poster. These are the initial thumbnail roughs before I settled on a layout. There's also a finished blueline for a panoramic version of the final design so the poster would fit in different advertising spaces."

MISCELLANEOUS | 95

The story behind the Gorbals Vampire ...

The Gorbals Vampire is a Glaswegian urban myth about a 7ft, iron-toothed vampire who stalked Glasgow's Southern Necropolis. It made history when, in 1953, hundreds of children as young as four years old stormed the cemetery with homemade weapons to hunt the creature. American comic books were quickly blamed for the juvenile uprising, with titles like Tales from the Crypt and The Vault of Horror extremely popular among Scottish youngsters at the time. It eventually inspired the government to introduce a law banning the sale of magazines and comic books portraying "incidents of a repulsive or horrible nature" to kids.

MISCELLANEOUS | 97

98 | **FRANK QUITELY** Drawings + Sketches

MISCELLANEOUS | 99

The Gorbals Vampire, cover illustration. © Frank Quitely (2016)

100 | **FRANK QUITELY** Drawings + Sketches

① XORN (XMEN)
② ZENITH (2000 AD)
③ ZATANNA
④ EMMA (XMEN)
⑤ QUESTION (PAX)
⑥ THING (FAN 4)
⑦ WONDER WOMAN
⑧ BATMAN
⑨ ANIMAL MAN
⑩ CAT (WE3)

⑪ FLEX MENTALLO ⑫ WOLVERINE (XMEN)

✱ FLASH

MISCELLANEOUS | 101

(13) SUPERMAN

A sketch of Grant Morrison with associated characters for spread in 2012 issue of Playboy magazine. The sketch includes annotations for 23 individual characters.

(16) BEAST (XMEN)

(17) KILL YOUR BOYFRIEND

(18) CYCLOPS (XMEN)

(19) FANNY (INVISIBLES)

(20) RAGGED ROBIN (INVISIBLES)

(21) KING MOB (INVISIBLES)

102 | **FRANK QUITELY** Drawings + Sketches

A commissioned sketch of Joker.

Finished pencils for a
Comic Book Legal Defense
Fund print (2011).

MISCELLANEOUS | 105

Miscellanous character sketches

106 | **FRANK QUITELY** Drawings + Sketches

MISCELLANEOUS | 107

Above and left:
Snapshot: Revelation!, DC Universe Legacies #8 © DC Comics (2011)

Blue line for sequence of Orion gearing up to fight Kalibak. This story, written by Len Wein, is a retelling of Jack Kirby's New Gods from the perspective of a civillian in the story.

108 | **FRANK QUITELY** Drawings + Sketches

This page: Aged portraits of Scottish singer-songwriter Aidan Moffat and composer Bill Wells for cover of award-winning album Everything's Getting Older (2011).

Opposite: The Trick Shop in Millport, drawn for a Shelter charity auction with the theme 'Up Your Street'.

MISCELLANEOUS | 109

110 | **FRANK QUITELY** Drawings + Sketches

"I drew this while on holiday with my family in Florida. I wasn't used to the timezone yet, so I kept waking up at 5 or 6am. This was me sitting at the back of our villa with my morning coffee sketching the pool when the water was still, before the pool filter switched on."

MISCELLANEOUS | 113

"These pages are me trying out a new brush pen. They're just doodles. There's a character there, his working name is the Homemade Hitman. I might be doing something with him in the future."

Thumbnails and a floorplan for an upcoming story collection with working title Close Calls. Each of the stories takes place in the same block.

MISCELLANEOUS | 115

(Handwritten notebook page with sketches and notes)

- GREGORY
- EGYPT SHOWER
- DRYING ARMS
- (LOOK AT OLD MAN SLEEPING) FAT LADY NAKED
- EMPTY
- PESTO HEAD IN HANDS
- EGYPT
- JOHN OLDMAN FIGHT FAT LADY
- PESTO
- B'HEIDS
- RUG
- HEAD IN HANDS OR LOOKING OUT
- STAIRCASE
- SANDSTONE
- ROUGHCAST or RED BRICK
- PESTO. BOTTOM GLASS
- (GROOMS) (COFFIN) (MEETING) (WEIRD SCIENTIST / GENETICIST)
- MIRROR
- HOUSE COAT SHAVING
- COFFIN P.
- BZZT
- BATH LIVING FIXING HAIR
- ON COUCH CF
- F F
- BRUSHING TEETH
- BRAW
- 1ST RHP 1ST LHP
- BZZT
- CLOCK EARLY
- SITTING / SLEEPING
- LEAVES WITH BROLLY
- TOP E PERS.
- MIRROR
- MIDDLE FLOOR PERSPECT
- GR. N. PBLS?

Ed's note: Quitely has "no recollection" of sketching these characters and acknowledges that socks and sandals are "not a good look".

MISCELLANEOUS | 117

Finished pencils for a cover
of **Django Unchained** #5
(©Visiona Romantico, Inc 2013)

"This is a quick sketch of Alan Bennett. I was dipping in and out of Keep On Keeping On at the time and I kept taking the dust cover off, so I had the photo of him sitting on my studio desk.

MISCELLANEOUS | 119

Ed's note: Quitely's sketchbooks contain everything from thumbnail roughs and character sketches to everyday notes. Some of these notes - which included bank details and a detailed recap of dreams from the night before - had to be omitted because they were, in Quitely's words, "too personal to share."

120 | **FRANK QUITELY** Drawings + Sketches

MISCELLANEOUS | 121

Miscellanous character sketches

122 | **FRANK QUITELY** Drawings + Sketches

Rough thumbnail sketches of a zombie granny, which became one of 12 variant covers for **The Walking Dead** #100.

MISCELLANEOUS | 123

The Walking Dead, #100, variant cover. © Image, Robert Kirkman (2012)

124 | **FRANK QUITELY** Drawings + Sketches

Credits:
Comic Book Legal Defense Fund poster © Frank Quitely (2011)
Django Unchained, #5 cover. © Visiona Romantica, Inc (2013)
Everything's Getting Older, album cover © Frank Quitely (2011)
Jupiter's Circle, vol. 1, #4 cover. © Netflix Studios, LLC and Netflix Global, LLC (2015)
Jupiter's Circle, vol. 1, #6 cover © Netflix Studios, LLC and Netflix Global, LLC (2015)
Jupiter's Circle, vol. 1, #2 cover © Netflix Studios, LLC and Netflix Global, LLC (2015)
Jupiter's Legacy, vol. 1, #1 pp.13. © Netflix Studios, LLC and Netflix Global, LLC (2016)
Jupiter's Legacy, vol. 1, #1 pp. 17-18. © Netflix Studios, LLC and Netflix Global, LLC (2016)
Jupiter's Legacy, vol. 2, #5 cover. © Netflix Studios, LLC and Netflix Global, LLC (2017)
Jupiter's Legacy, vol. 2, #4 cover. © Netflix Studios, LLC and Netflix Global, LLC (2017)
Jupiter's Legacy, vol. 2, #2 cover. © Netflix Studios, LLC and Netflix Global, LLC (2017)
Jupiter's Legacy, vol. 2, #1 cover. © Netflix Studios, LLC and Netflix Global, LLC (2017)
Jupiter's Legacy, vol. 2, #2 pp. 43 © Netflix Studios, LLC and Netflix Global, LLC (2017)
Nothing to Declare. © **Interference Pattern**, Once Were Farmers, Studio Temba, Frank Quitely (2017)
Snapshot: Revelation!, DC Universe Legacies #8 © DC Comics (2011)
The Gorbals Vampire, cover illustration. © Frank Quitely (2016)
The Multiversity: Pax Americana. "In Which We Burn", pp 12-13, 35. © DC Comics (2015)
'The Super Psyche of Comic Book Shaman Grant Morrison' in Playboy, illustration for profile. © Playboy Enterprises (2012), all characters copyright their respective owners.
The Walking Dead, #100, variant cover. © Image, Robert Kirkman (2012)
We3: The Deluxe Edition, pp. 54-55, 50-51 © Vertigo/ DC Comics (2004)